How To Draw Superheroes : Pencil Drawings Step By Step

Pencil Drawing Ideas for Absolute Beginners

By Gala Publication

Published By:

Gala Publication

ISBN-13: 978-1515184584
ISBN-10: 1515184587

©Copyright 2015 – Gala Publication

ALL RIGHTS RESERVED. No part of this publication may be reproduced or transmitted in any form whatsoever, electronic, or mechanical, including photocopying, recording, or by any informational storage or retrieval system without express written, dated and signed permission from the author.

Table of Contents

Learn To Draw Superhero 10 Characters:..
 Learn To Draw Dr Doom....................................
 Learn To Draw Hulk..
 Learn To Draw Magneto......................................
 Learn To Draw Rouge ..
 Learn To Draw Spiderrman
 Learn To Draw Storm...
 Learn To Draw Superheroes
 Learn To Draw Thor ...
 Learn To Draw Wolverine
 Learn To Baby Tighten..

Dr Doom

Step 1

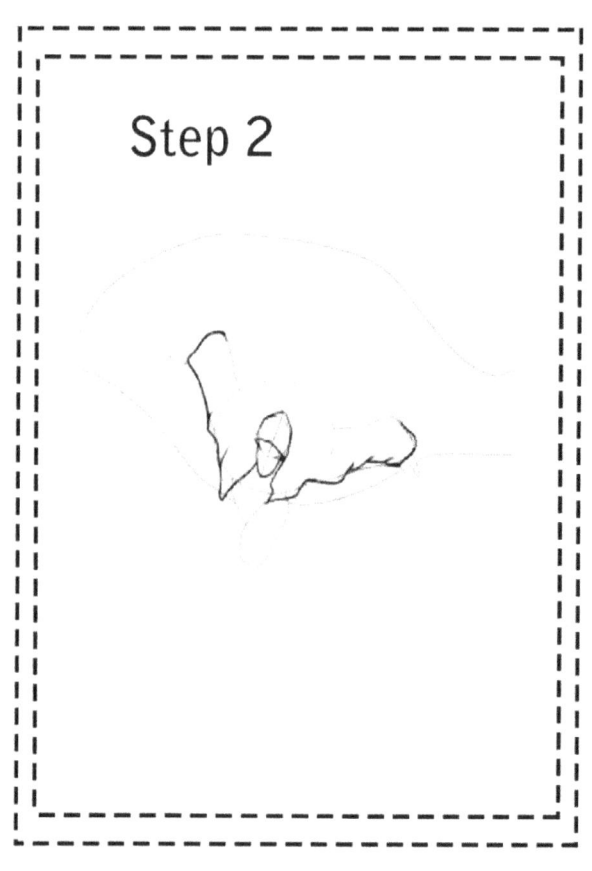

Step 3

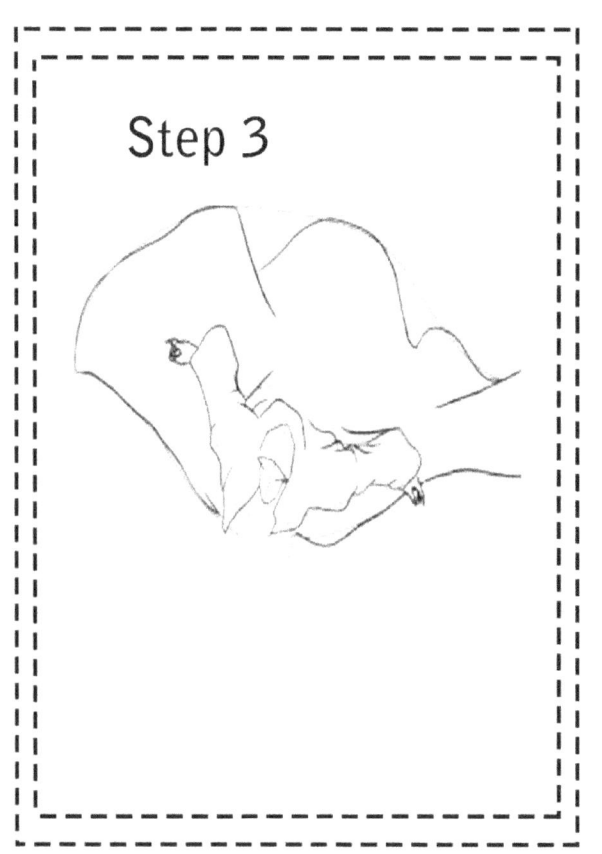

Step 4

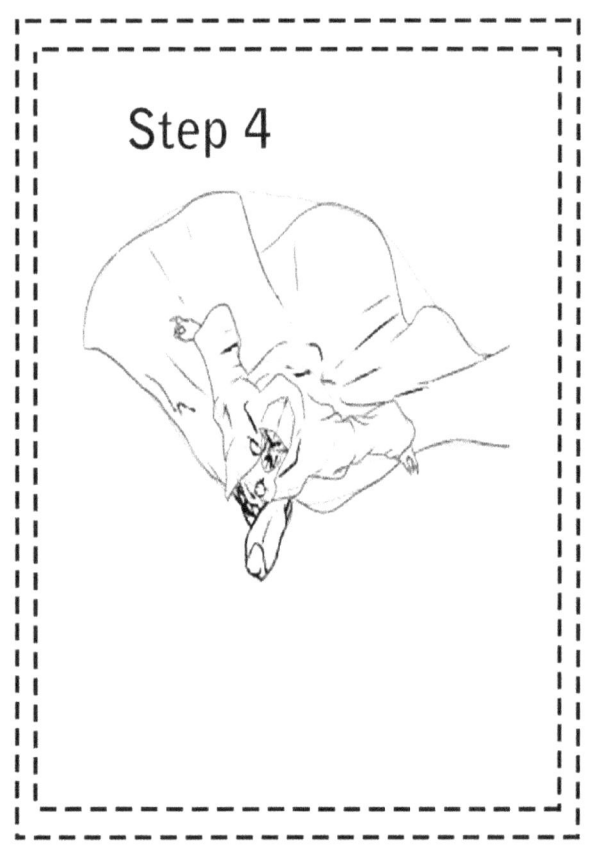

Step 5

Hulk

Step 1

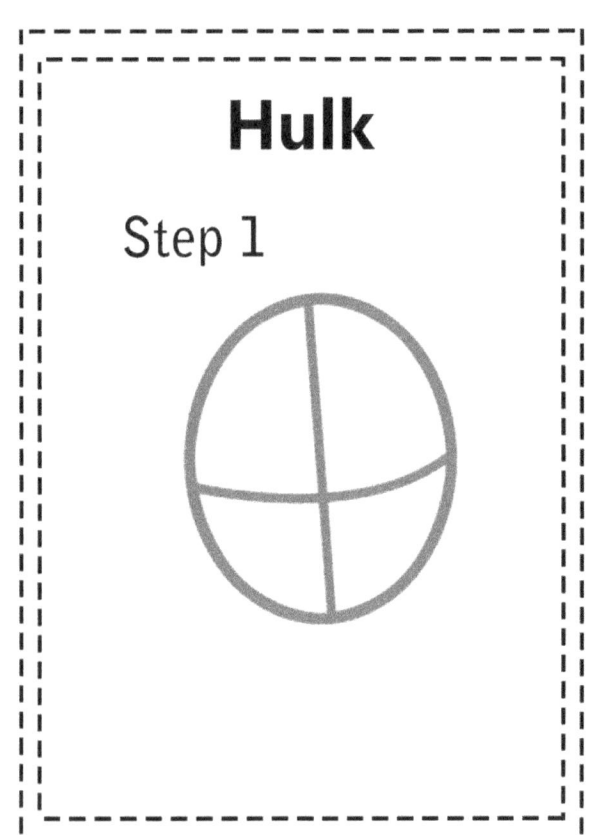

Step 2

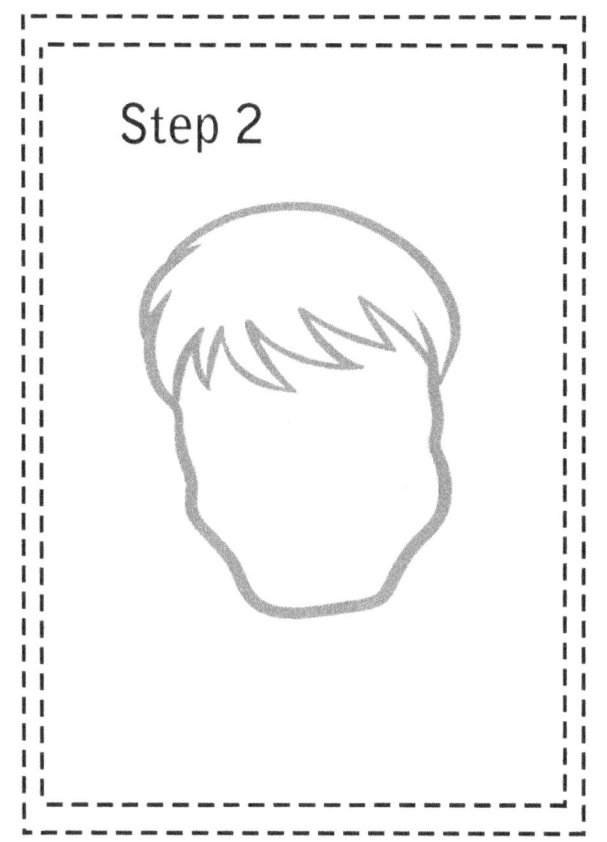

Step 3

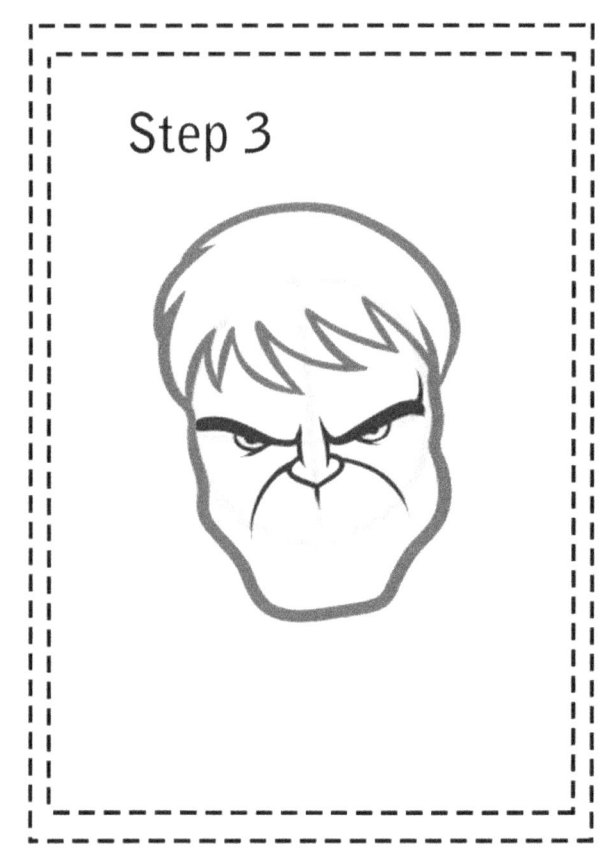

Step 4

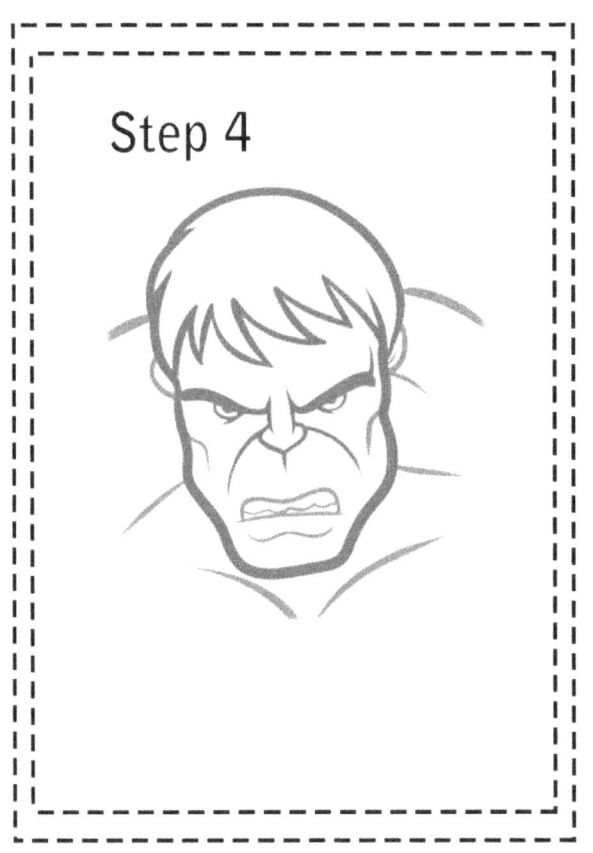

Step 5

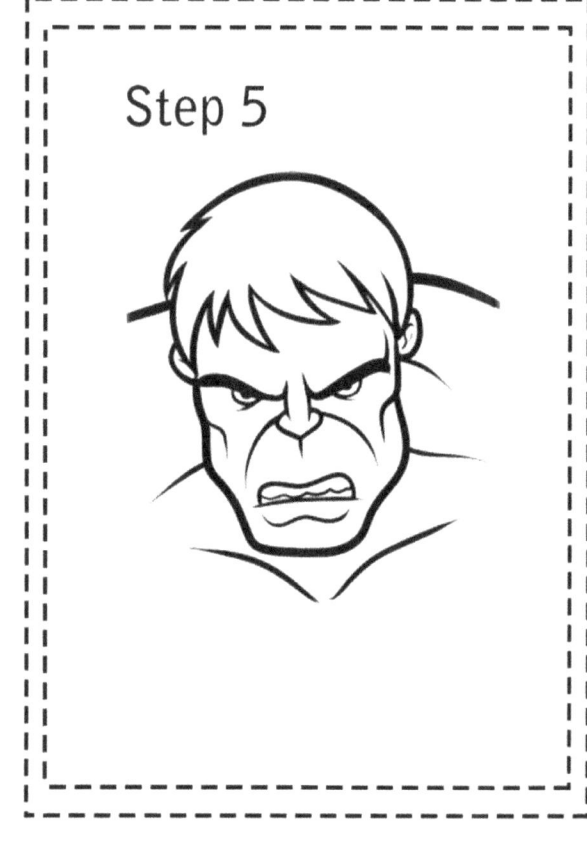

Magneto

Step 1

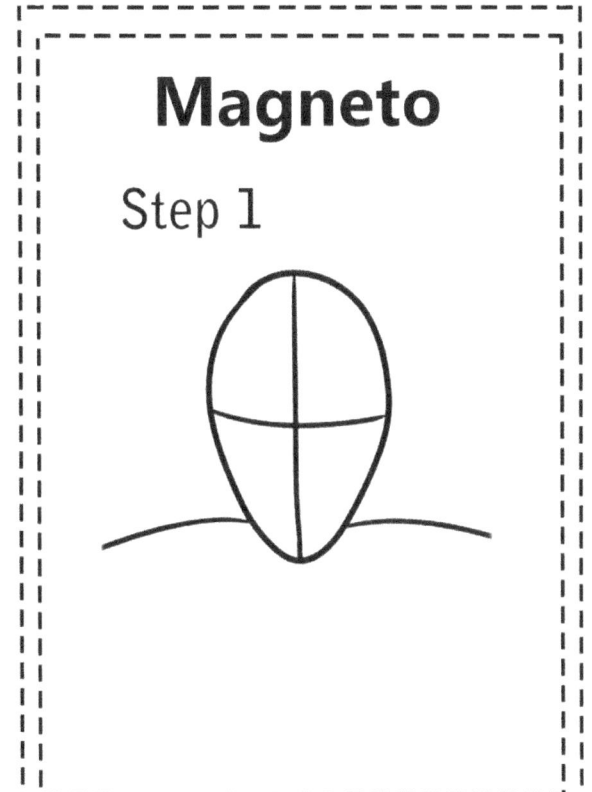

Step 2

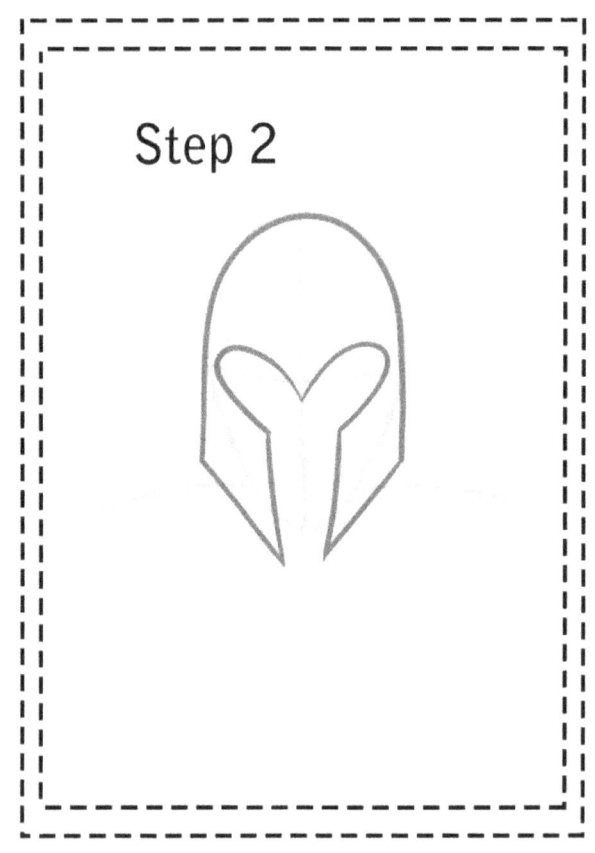

Step 3

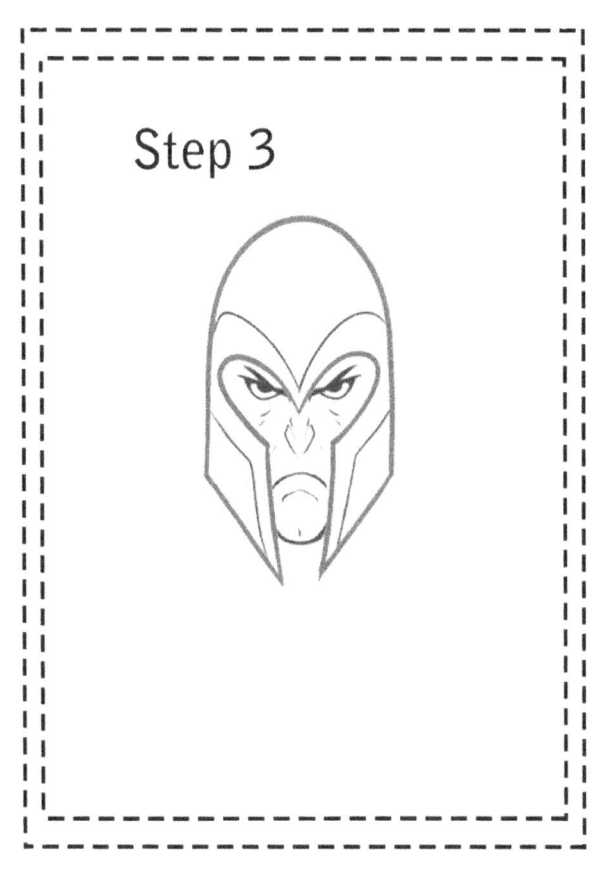

Step 4

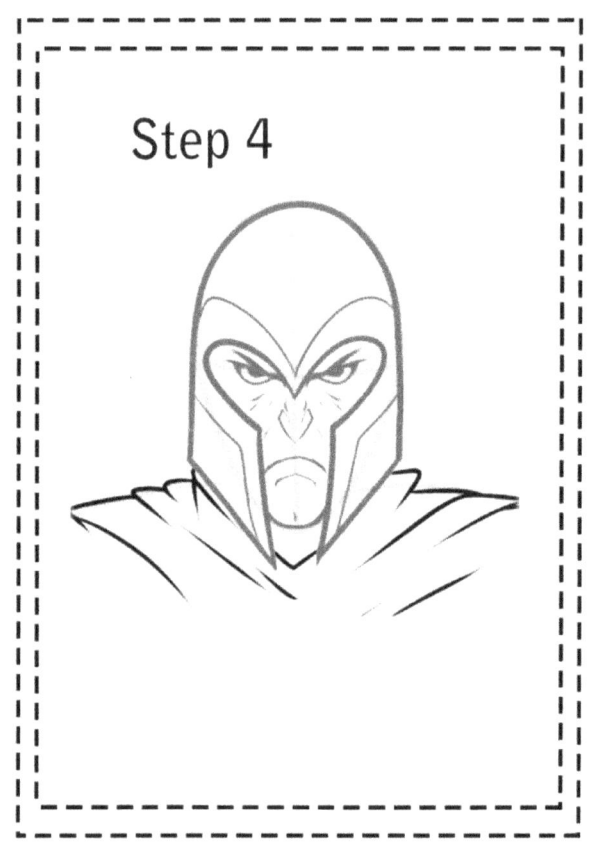

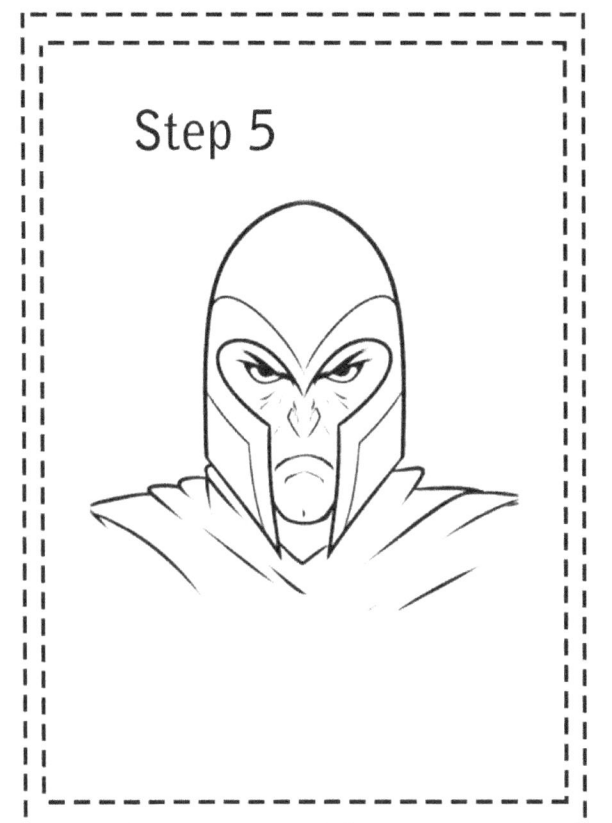

Rouge

Step 1

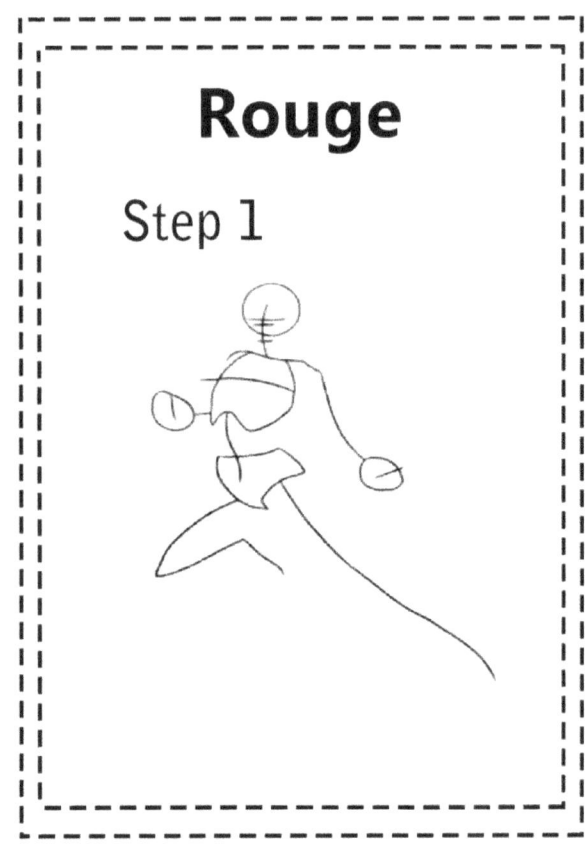

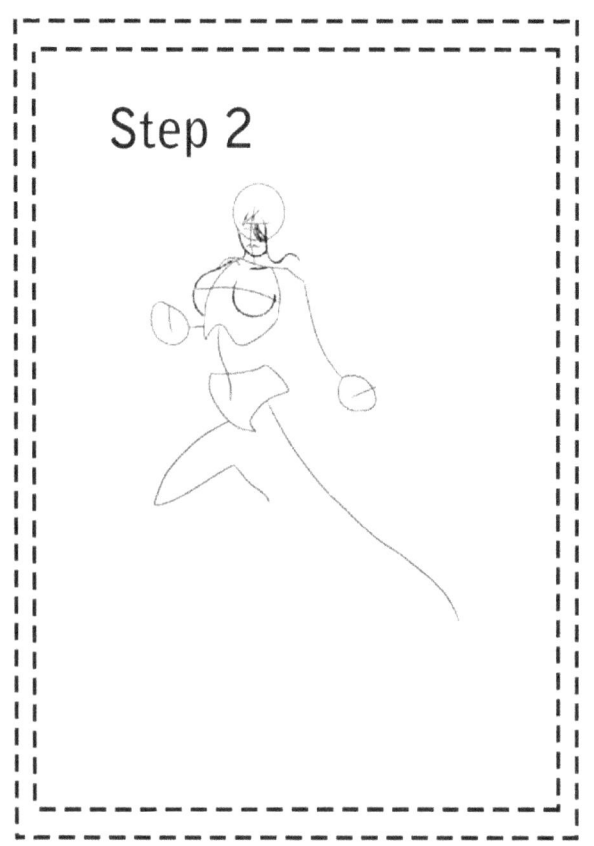

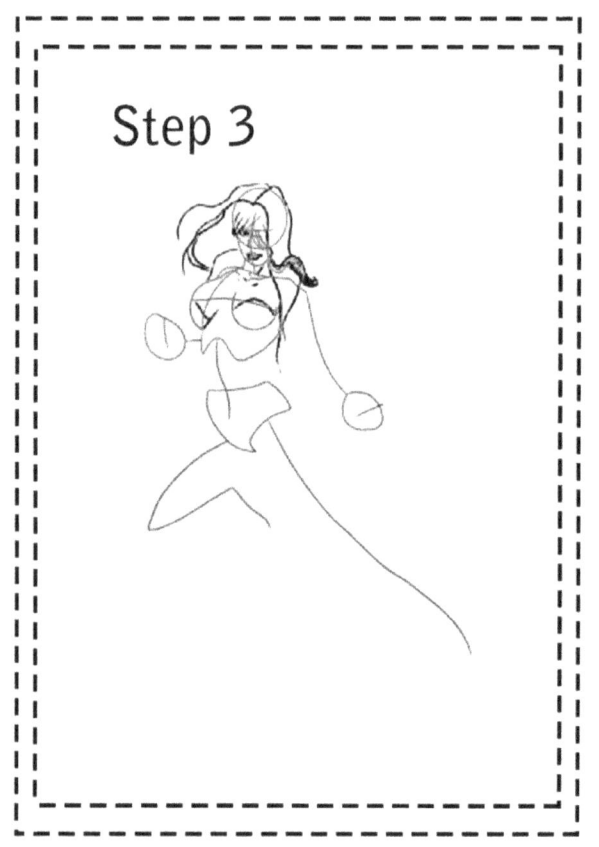

Step 4

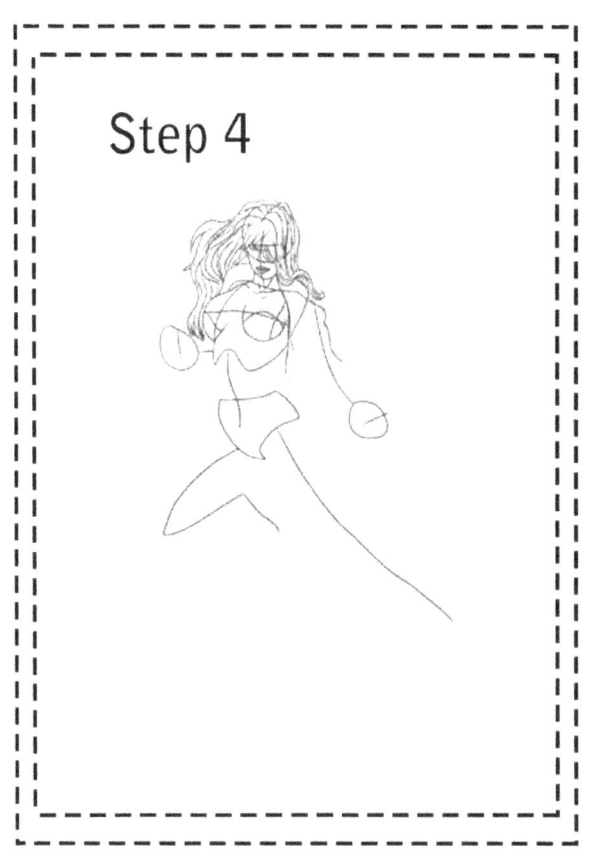

Step 5

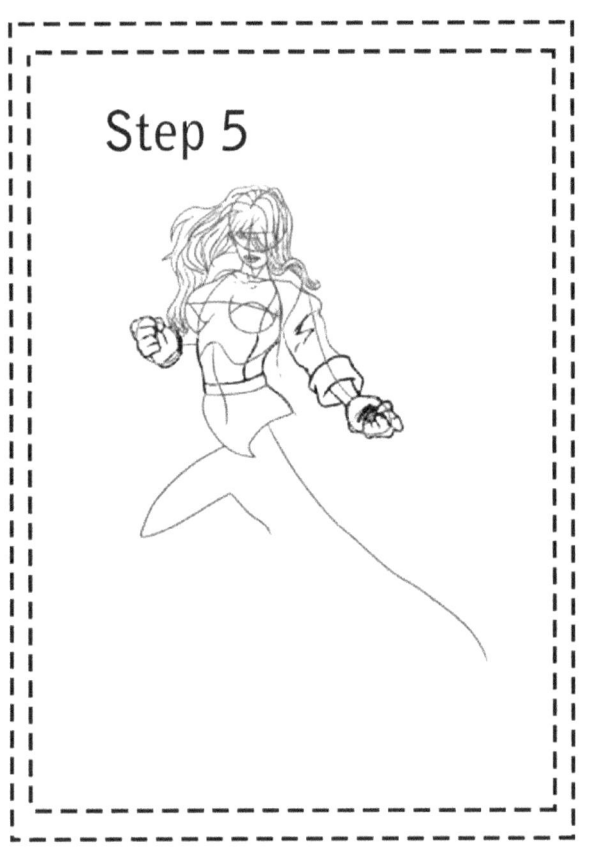

Step 6

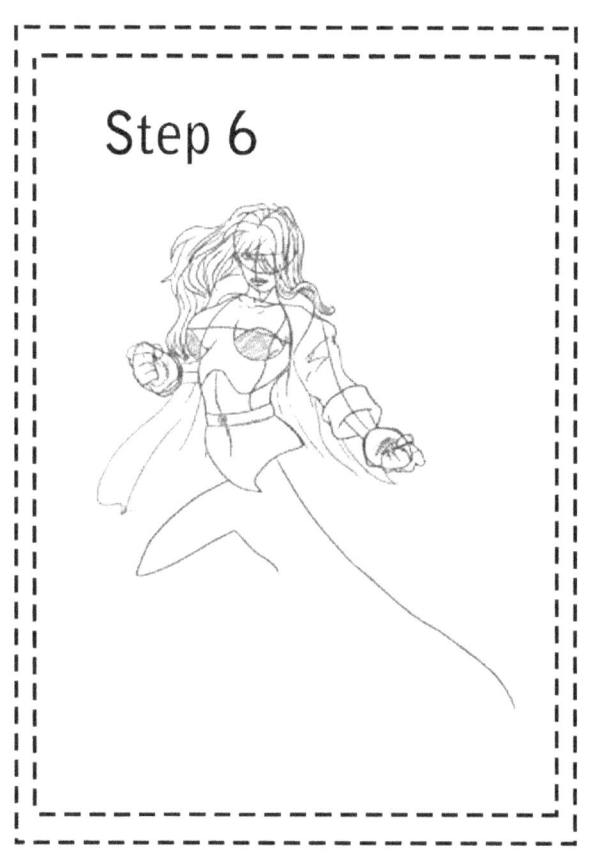

Step 7

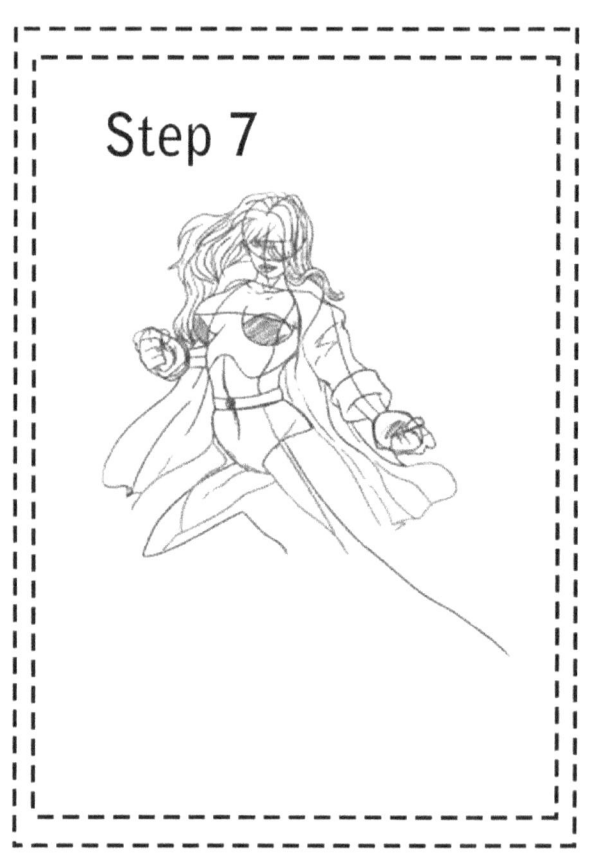

Step 8

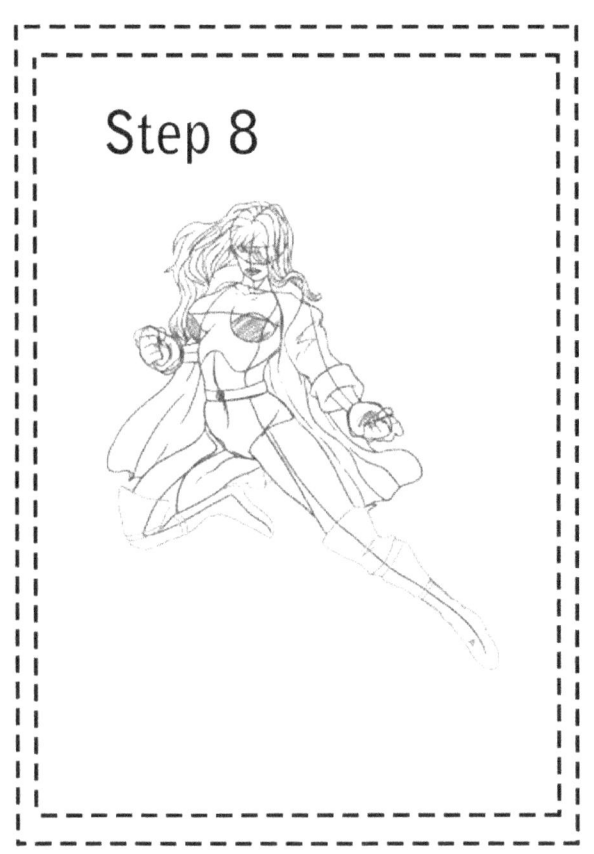

Step 9

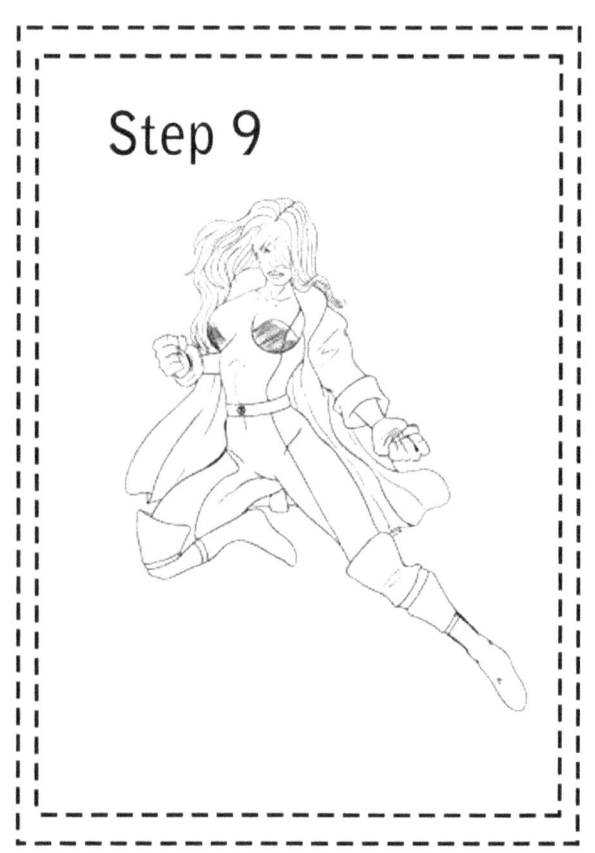

Spiderman

Step 1

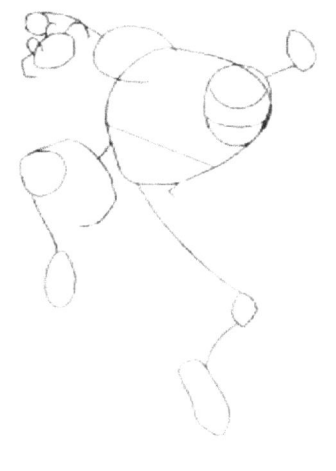

Step 2

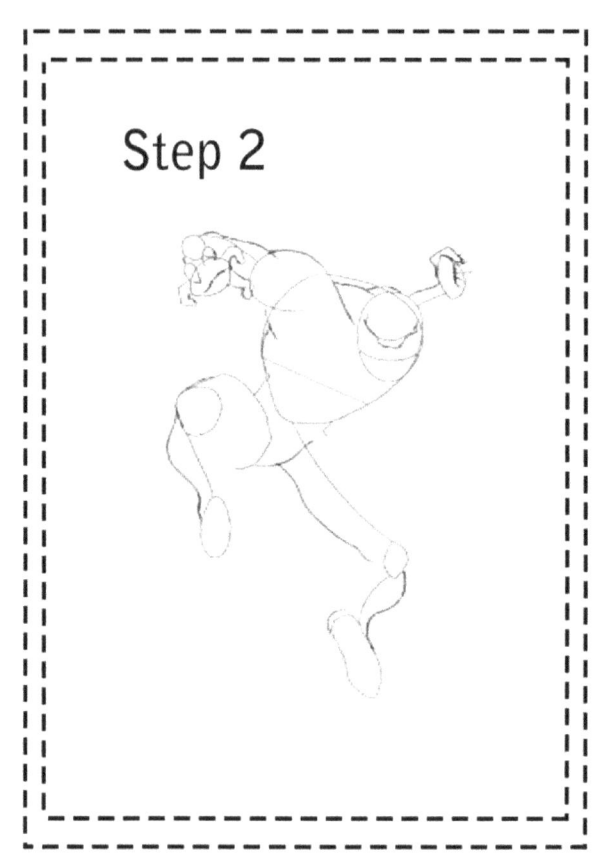

Step 3

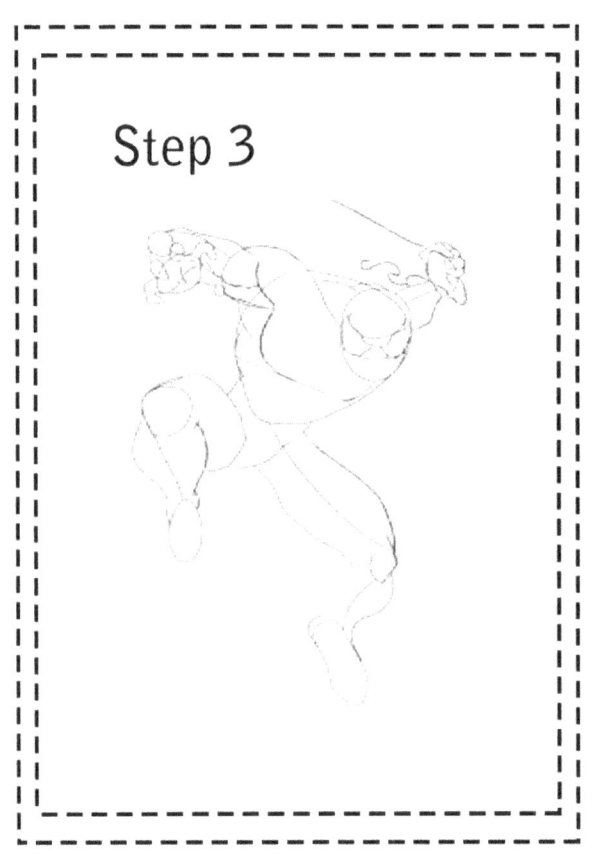

Step 4

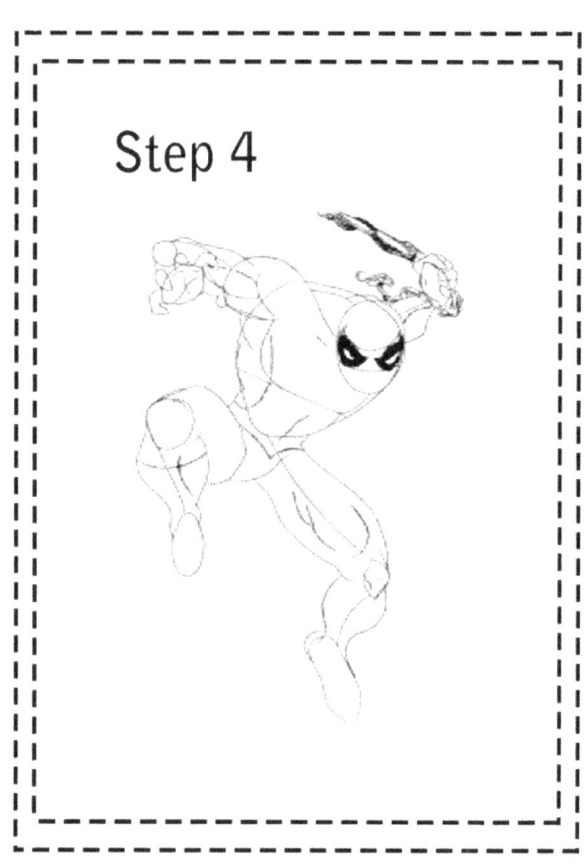

Step 5

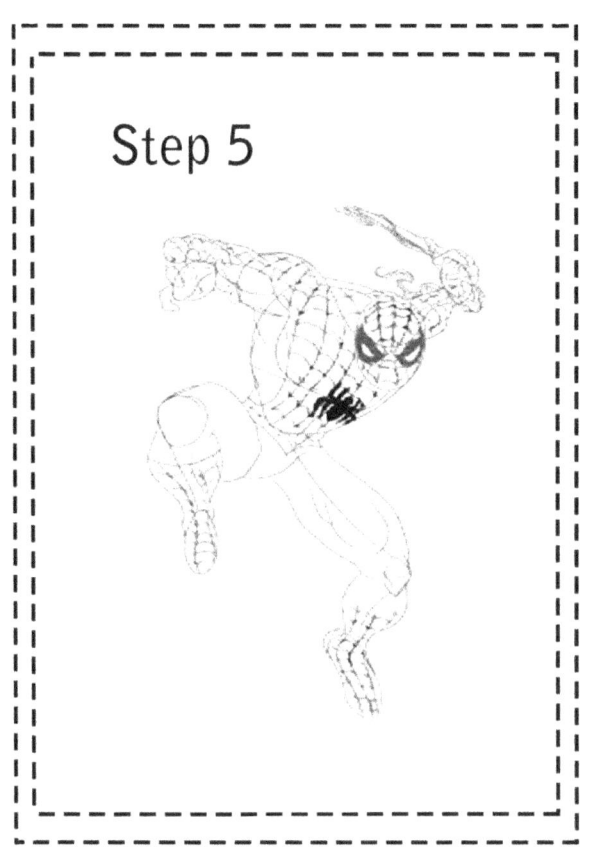

Storm

Step 1

Step 2

Step 3

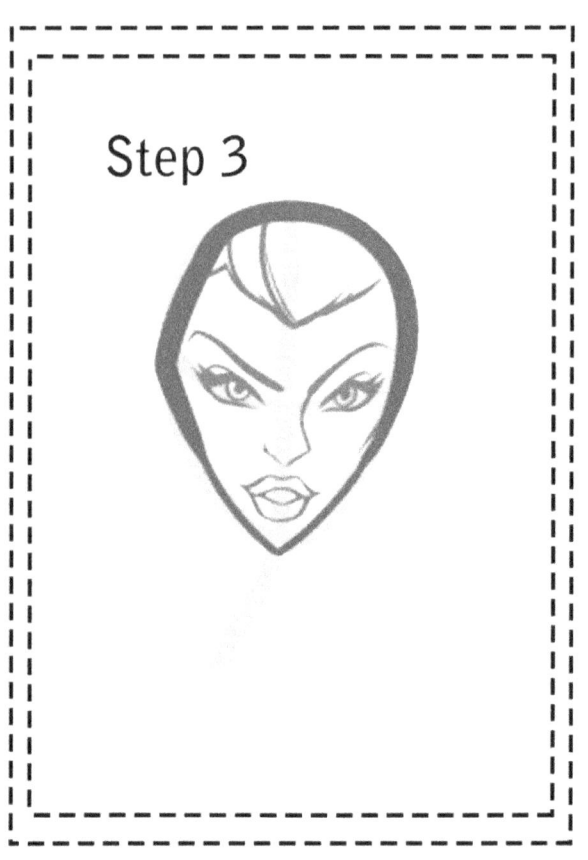

Step 4

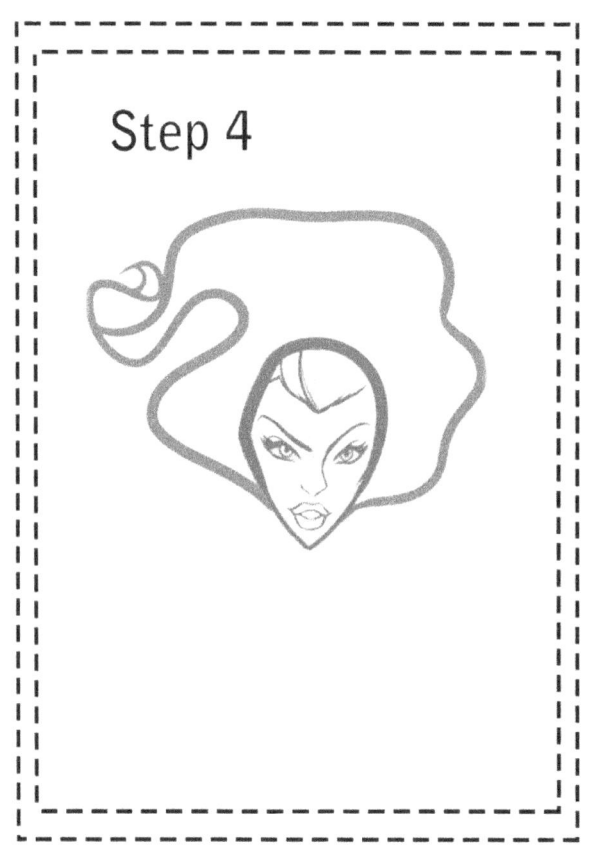

Step 5

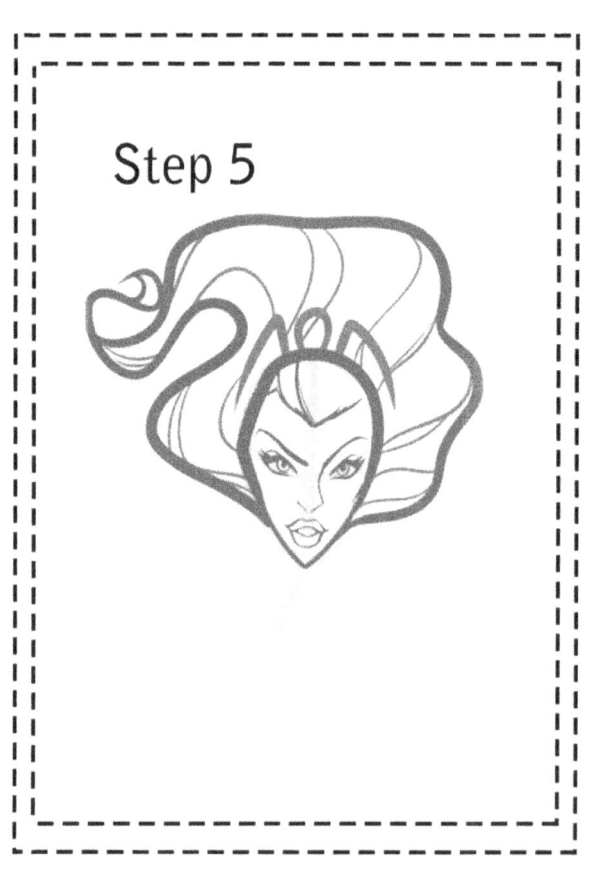

Step 6

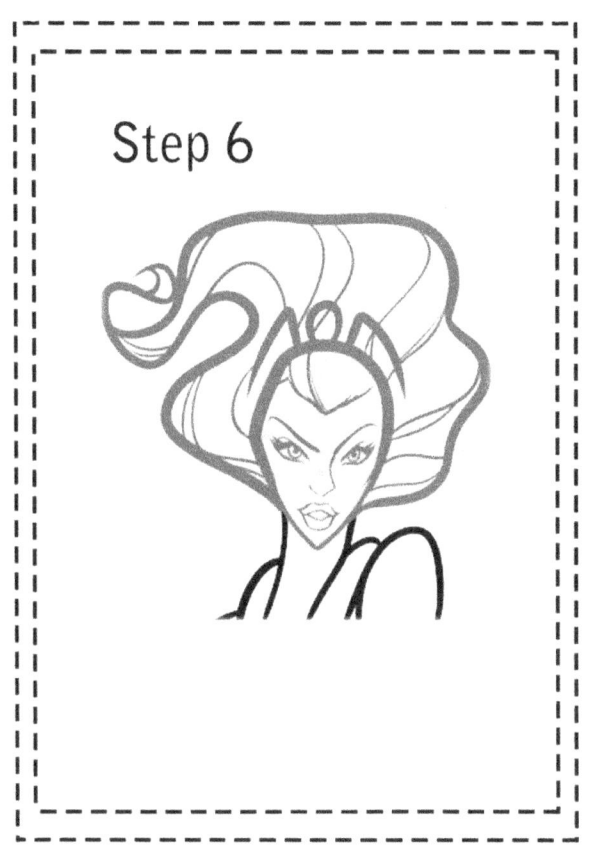

Step 7

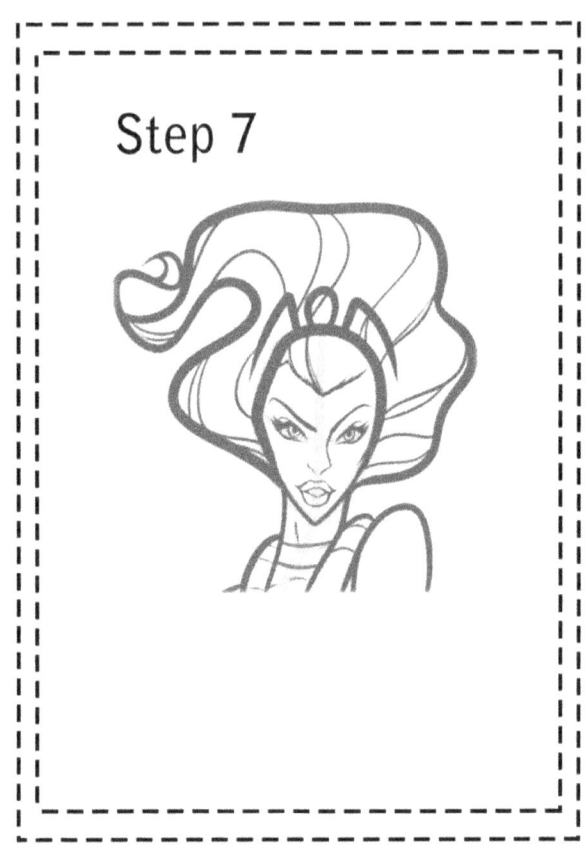

Step 8

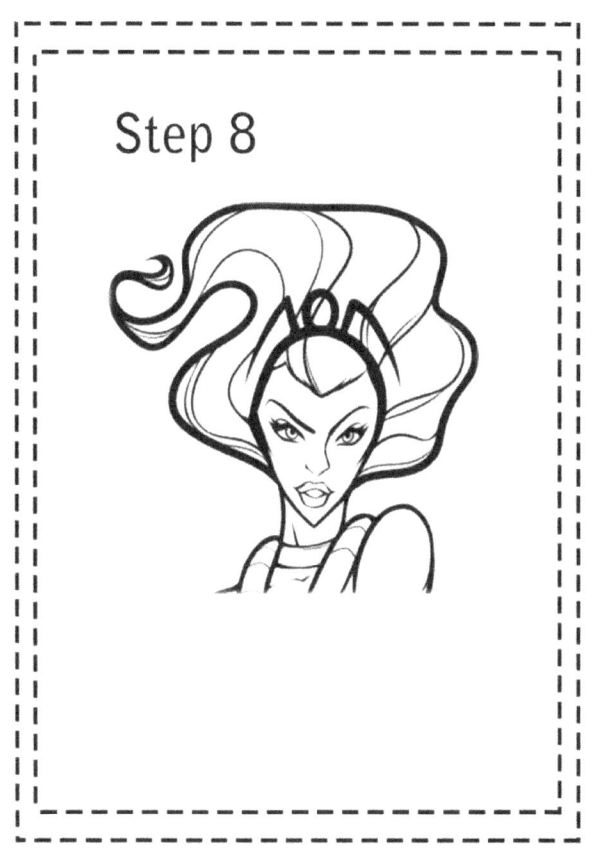

Superheroes

Step 1

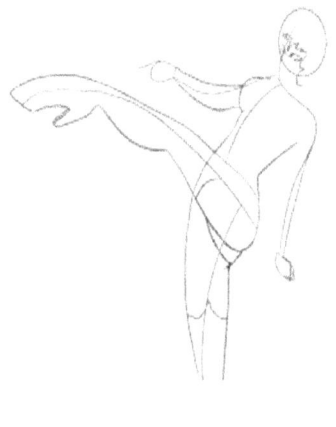

Step 2

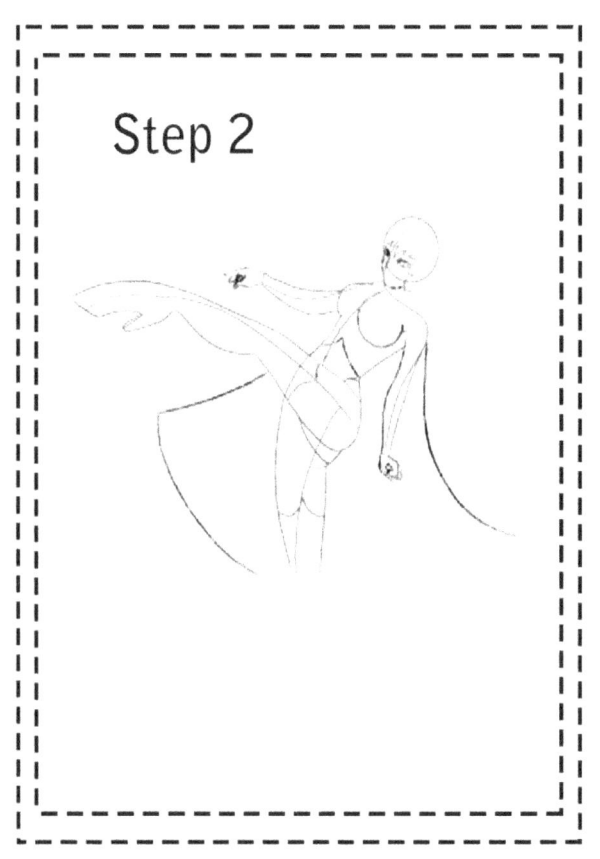

Step 3

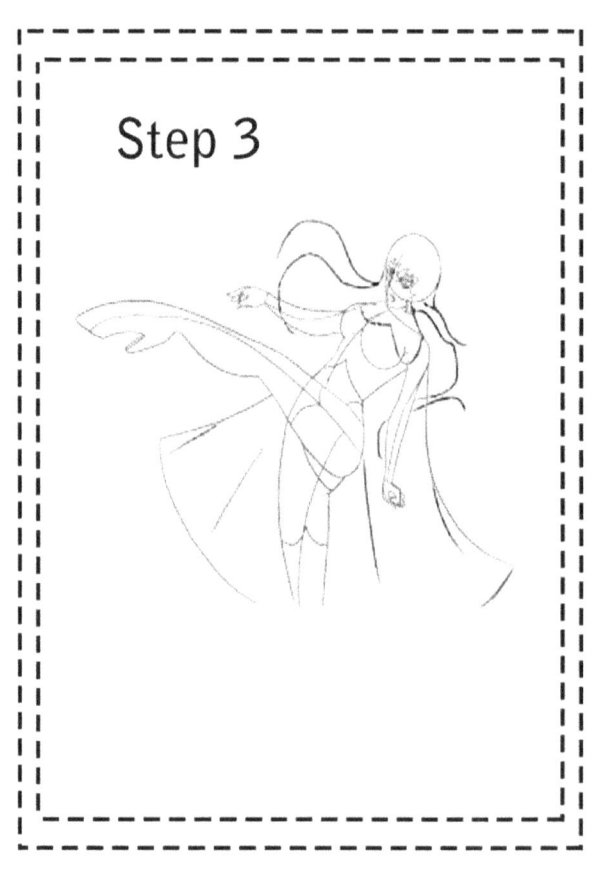

Step 4

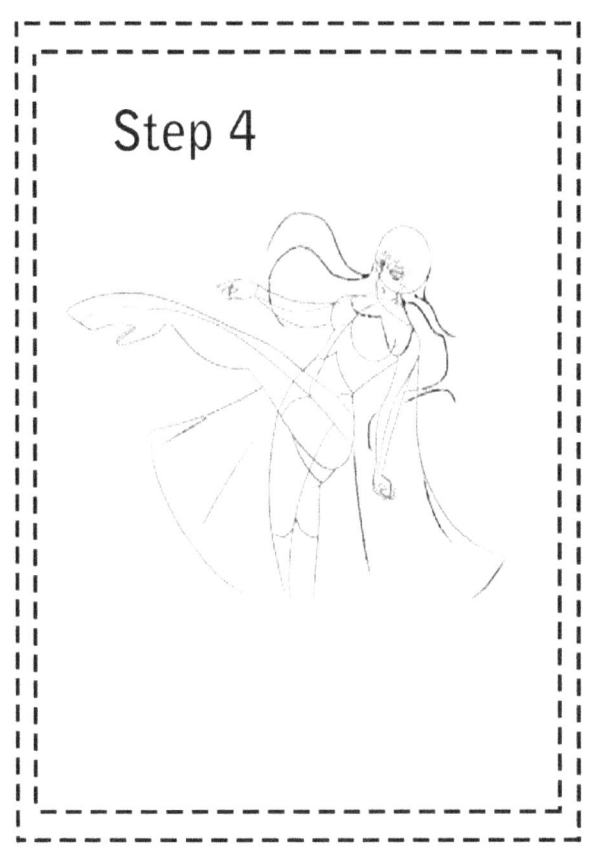

Step 5

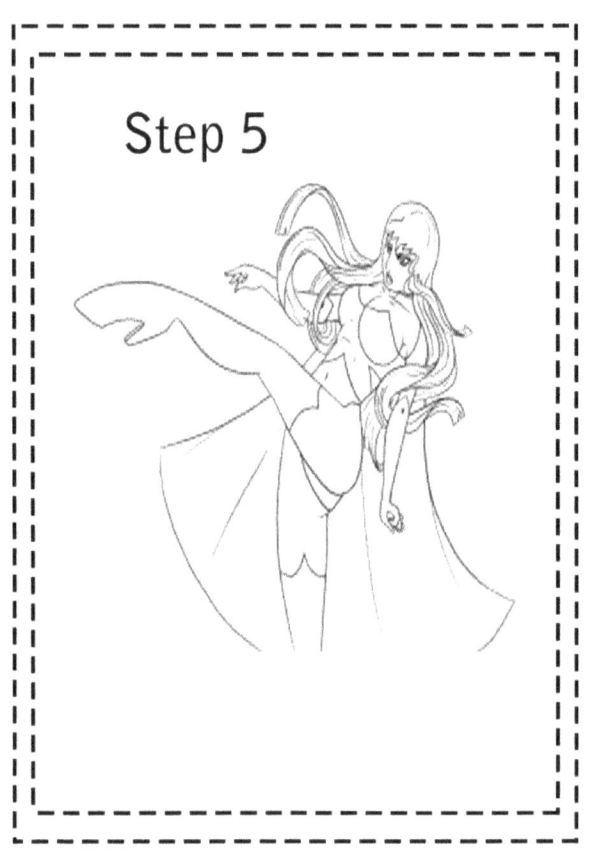

Thor

Step 1

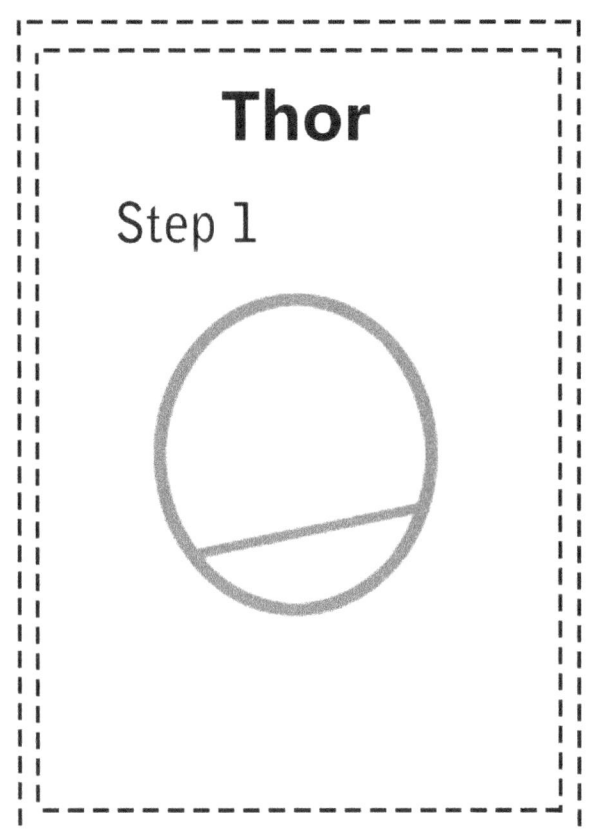

Step 2

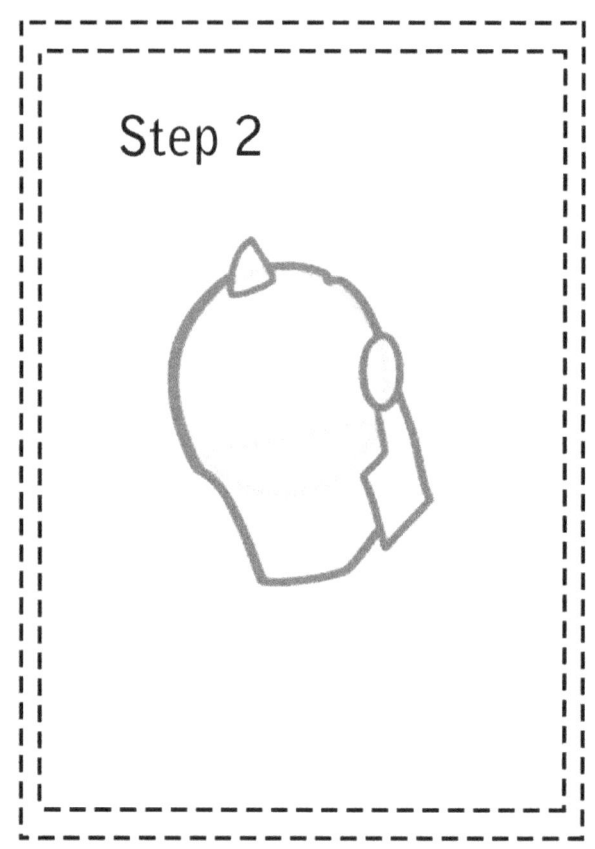

Step 3

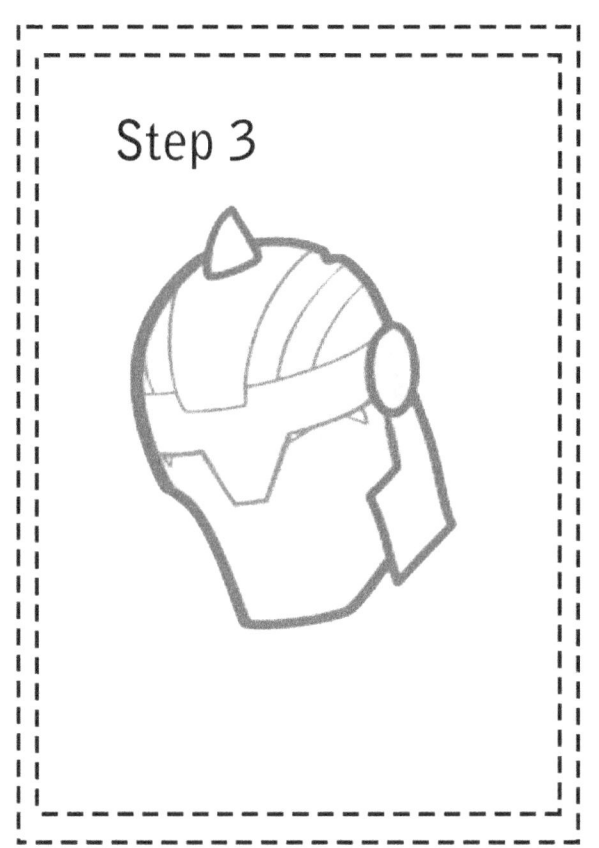

Step 4

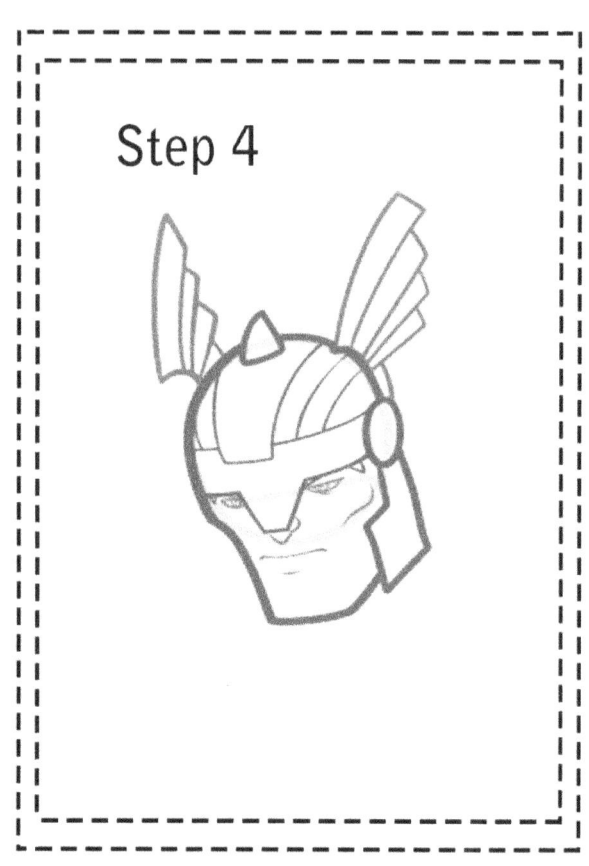

Step 5

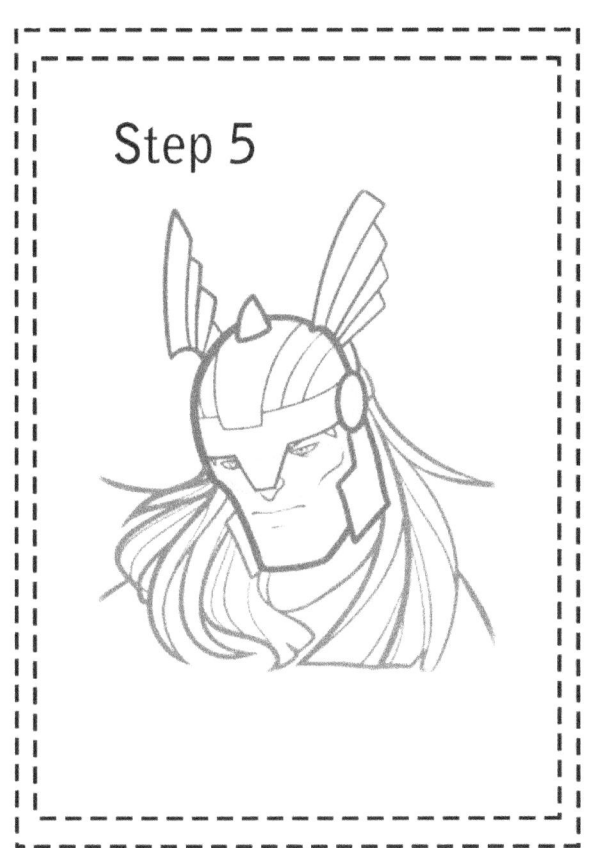

Step 6

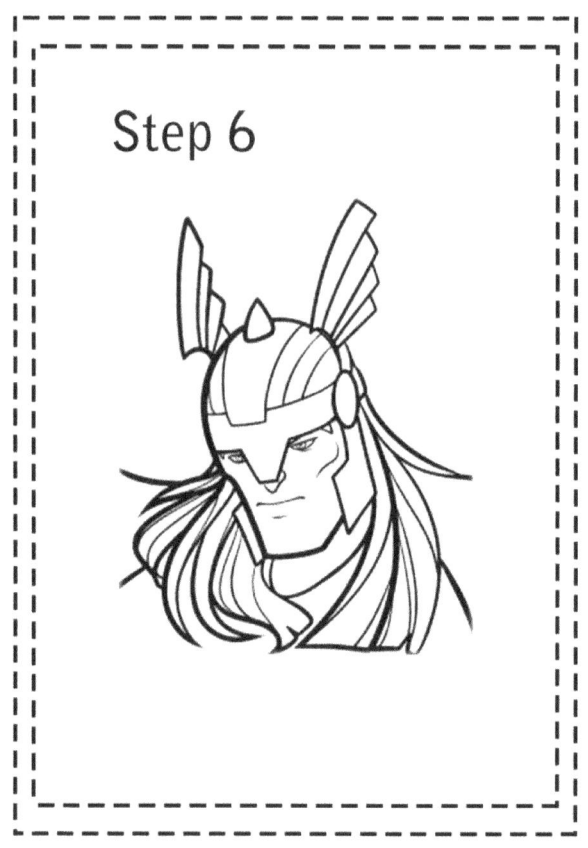

Wolverine

Step 1

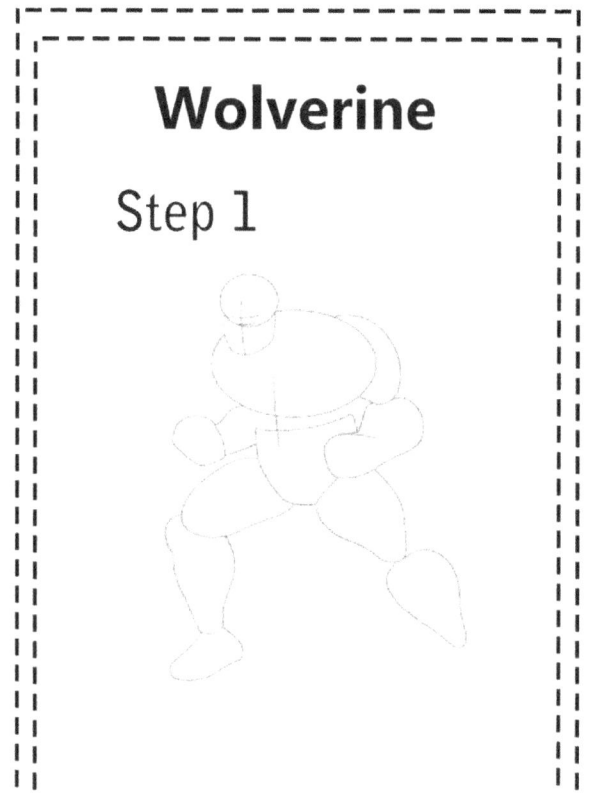

Step 2

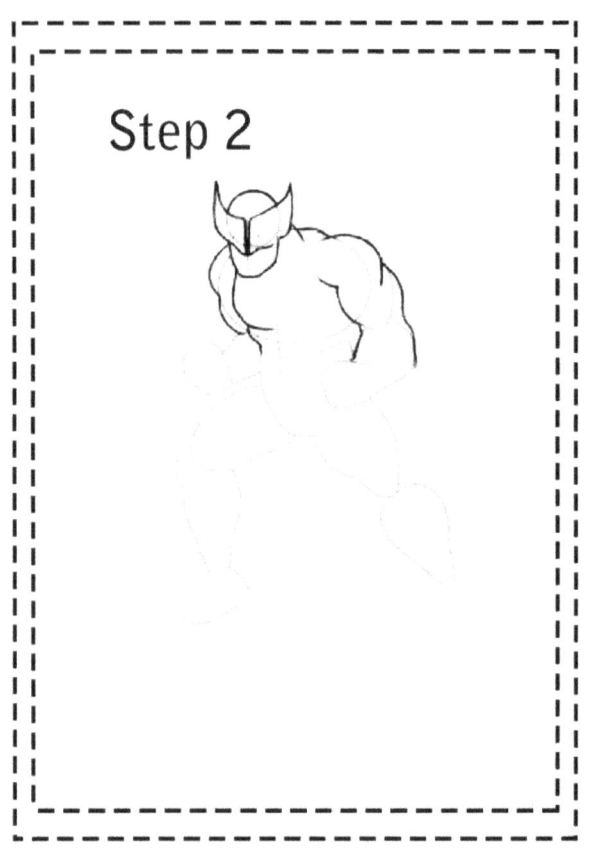

Step 3

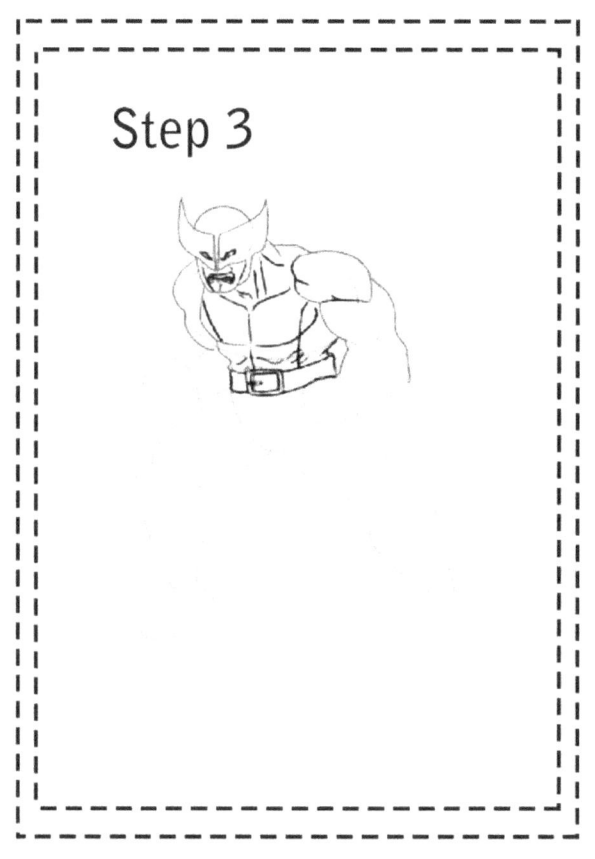

Step 4

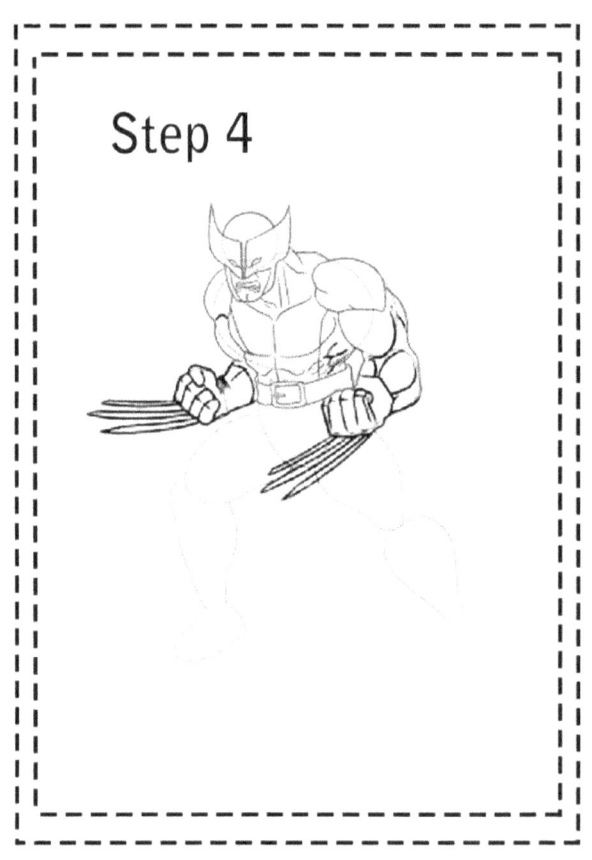

Step 5

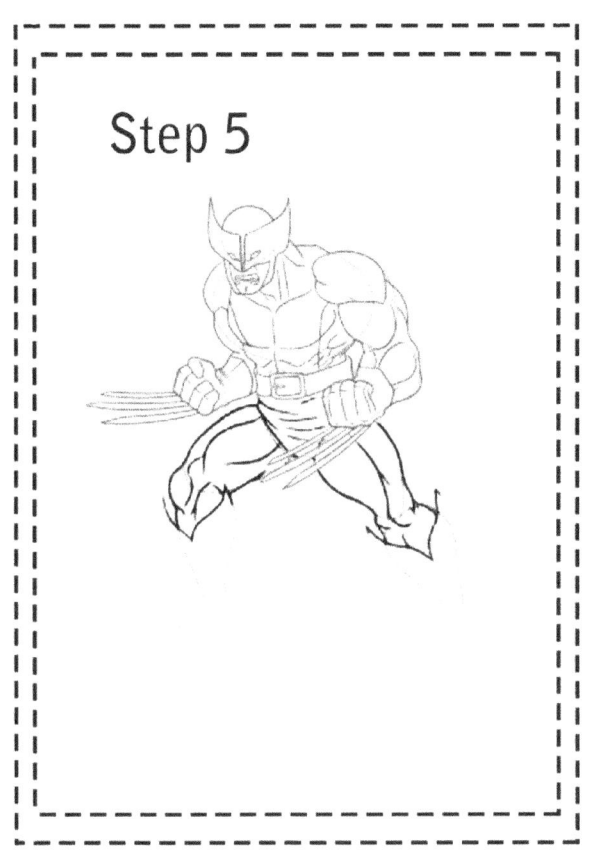

Step 6

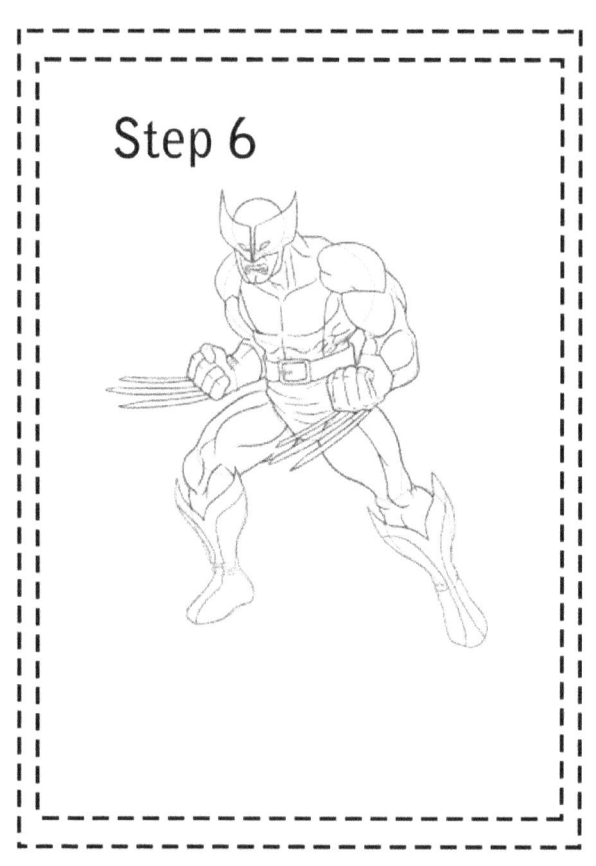

Step 7

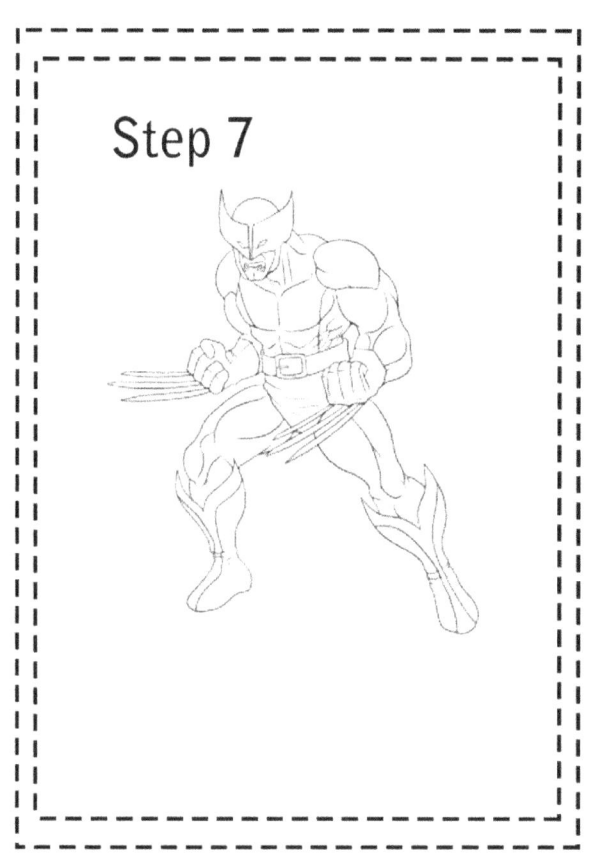

Tighten

Step 1

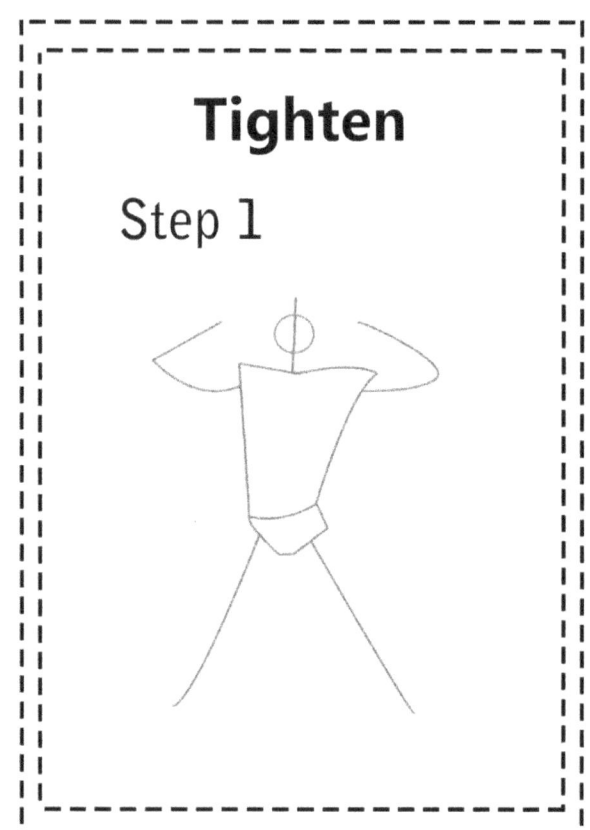

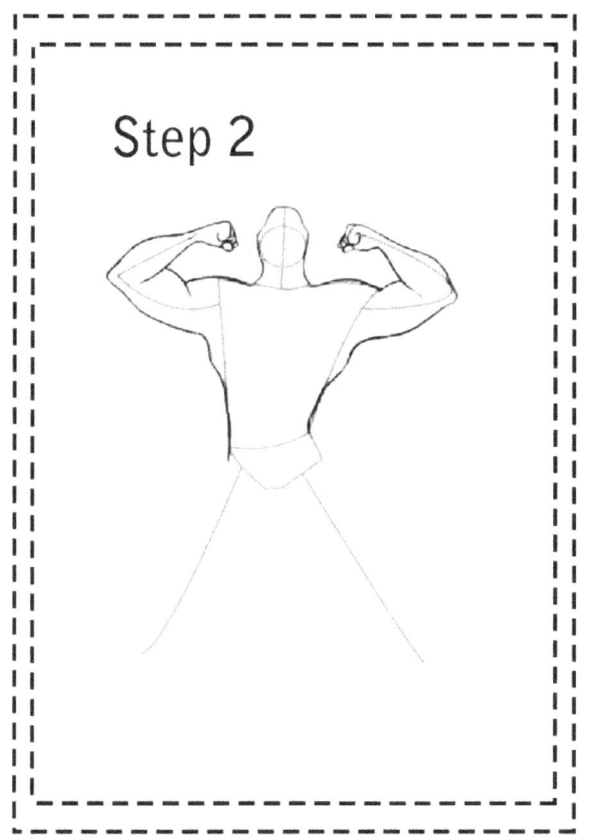

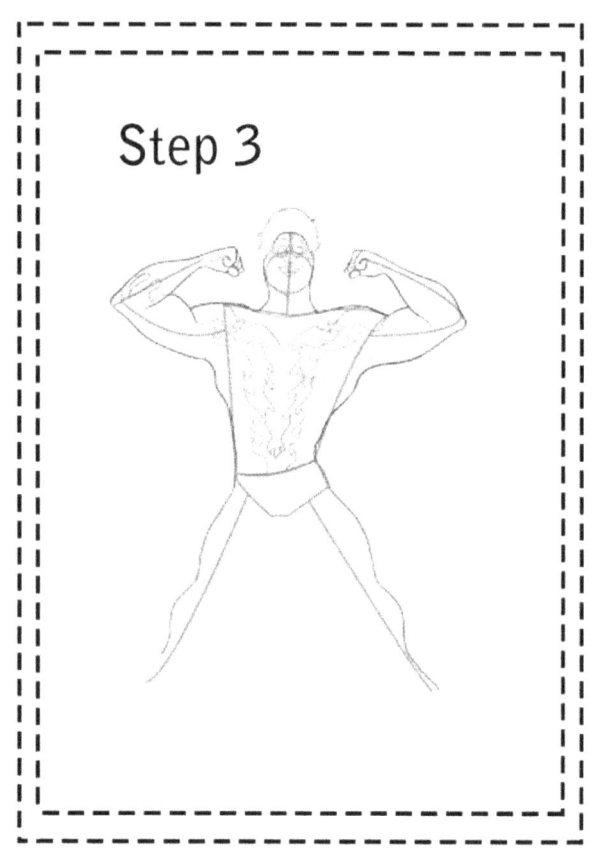

Step 4

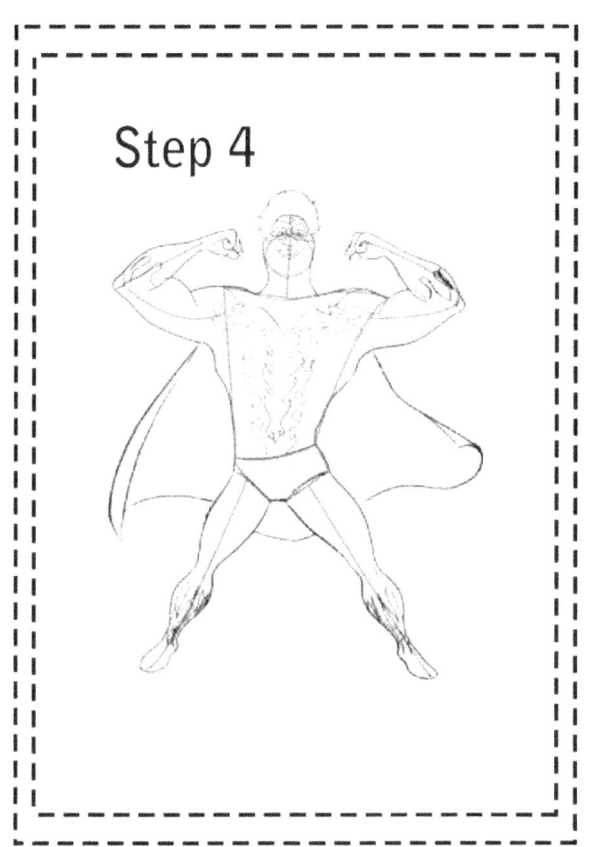

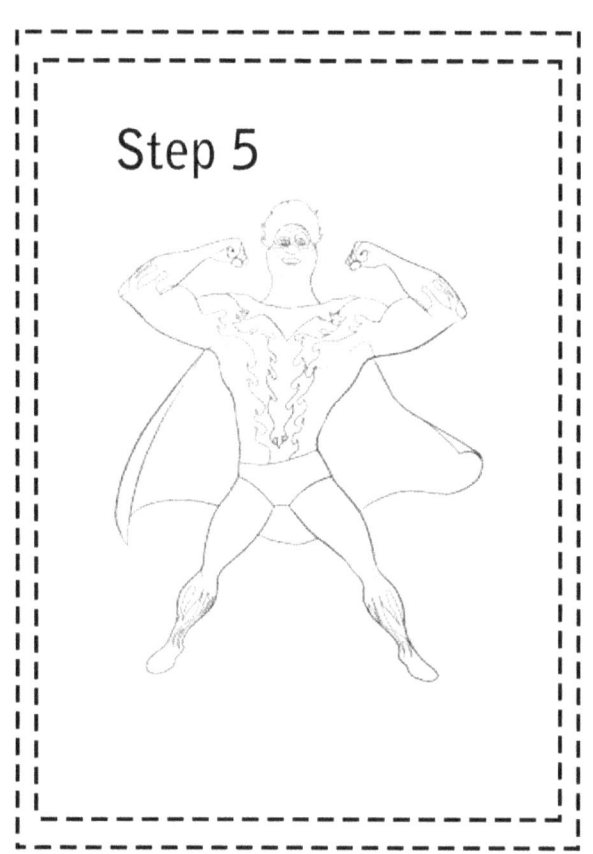
Step 5

LL RIGHTS RESERVED. No part of this publication may be reproduced or transmitted in any form whatsoever, electronic, or mechanical, including photocopying, recording, or by any informational storage or retrieval system without express written, dated and signed permission from the author.

www.ingramcontent.com/pod-product-compliance
Lightning Source LLC
Chambersburg PA
CBHW072309200526
45168CB00014B/1129